EASEL SERIES

Oils

A new way to learn how to paint

BARRON'S

This book is designed to help you learn how to paint with oils. The book's pages are read vertically rather than horizontally, and this means it can be folded over and turned into an easel.

A brief introductory section which explains the basic techniques of oil painting is followed by seven exercises shown in full detail, in several steps or stages. On the even-numbered pages, we teach you how to complete each stage without difficulties. On the odd-numbered pages, the results are shown in a full-page photograph that can be used as a model on the easel. (You may even trace from these pages if your drawing ability is not up to the task.)

This novel and practical format (it can either be read like a book or set up in the form of an easel) makes it easier to see all of the stages that each exercise has been divided into. Readers therefore have a clear view of the model, allowing them to enjoy trouble-free oil painting.

The methods
of oil painting

Solvents

Oil paints are not diluted with water but rather with turpentine. This special solvent, indispensable in oil painting, is obtained from pine resin, and is colorless with a strong odor. We can use turpentine to thin down the density of the paint until it is as fluid as a watercolor. The color becomes less saturated, turns transparent, can be easily corrected, and dries quickly. The usual way of commencing an oil painting is by using the color diluted with a lot of turpentine.

Areas painted in oil color diluted with solvent resemble watercolors, although they lack the delicate effect and homogeneity of the latter. In addition, they are not absorbed equally on the support, and they dry more slowly.

Diluted with turpentine, the color becomes more fluid and slides easily onto the support. It dries much more quickly than creamy color but loses its luster on doing so.

If the color is diluted with linseed oil, it takes on a homogeneous and smooth appearance. It keeps its shine once dry, although it takes a lot longer to dry. The oil may affect successive applications of color and crack the painting, making its use inadvisable.

If we do not dilute paints with solvent, the color offers much better covering power and is richer in oil. Nevertheless, diluting the paint with turpentine during the initial stages of the work is worthwhile.

Preparing colors

Oil colors are mixed on a palette that is usually made of varnished wood, but they can also be mixed on any other material that is not very absorbent. All colors can be mixed together, in any order, but we should avoid black and an excess of white as far as possible as they dirty and devitalize color mixes. Whenever feasible, we lighten a color by mixing it with another color different from white, and we darken it by mixing it with one that is not black. It is important to work on each new mix with a clean brush or a different brush, changing the solvent when it is very dirty.

Colors can be lightened or darkened with white and black or with related colors (colors related to green are yellow and blue). White and black drain color from mixes.

The way that colors are arranged on the palette depends on the artist's preferences. This is a logical and acceptable order: yellows, reds, earth colors, greens, and blues. White and black can be placed to the side of this series.

Colors from the same family are placed together to prevent very different colors from accidentally mixing.

The arrangement of colors should leave as much space as possible for mixing purposes.

On this palette, the white is placed away from the other colors, and a lot more space has been left around it for making color mixes.

Starting work on the canvas

The initial drawing for an oil painting is made in pencil or charcoal; we then go over the lines using strokes of very diluted color. These strokes should be general and simple, filling the canvas with large blocks. This done, the next stage is usually to "block in" the canvas, which means covering the spaces with diluted colors applied with rapid brushstrokes. Working in this way allows us to check the overall effect of the light and shadows in the composition before going on to add more detail using creamy color.

We create the initial drawing with a fine round brush that gives us control over the line. The color should be very diluted to ensure a light touch.

The initial layout and painting stage is known as the block-in phase: the entire composition is reduced to the most essential lines, and the spaces are painted using rapid and generic brushstrokes.

The fruits are represented by vague circles that help us plan the positioning of these elements in the overall work.

The color of the painted area is only approximate and is applied after dilution with a lot of solvent.

Fat over lean

An oil painting normally progresses by building up from a base of very diluted color toward an increasingly more dense layer of color. The diluted color is low in oil (lean), and the undiluted color is very rich in oil (fat). In its lean state, the painting can easily be modified: the new brushstrokes cover the previous ones, and the colors can be revised and adjusted. The oilier the layer of color, the more difficult it is to alter the colors without causing a muddy and murky effect. An oil painting does not necessarily have to be laden with thick color, meaning that the progression from lean to fat should be careful and gradual.

The progression from liquid to thick paint undergoes a process of successive enrichment of color. This process can be stopped when we have achieved harmony; we should avoid taking it too far.

We first use areas of
liquid paint where it is
not possible, or
convenient, to specify
or adjust the color.

Using a drier brush,
we apply color in
small quantities.
We then consolidate
the true coloring a
little more.

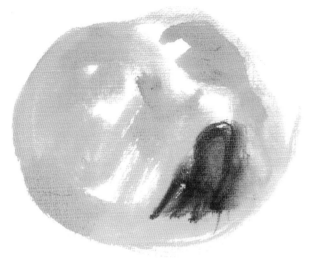

The color can now be
applied more thickly as
we know exactly which
color corresponds to
each area of the
subject.

Without increasing
the thickness of the
color, we build up
brushstrokes and
carefully blend them
into one another.

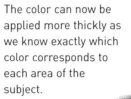

Applying impastos

Impasto means applying the color (with a brush or a palette knife) in the creamy form in which it leaves the tube, without the use of a solvent. This can be done during the final phase of the work or from the beginning, if the subject so requires it and if we have a very clear picture of the result we want to obtain. Once we have painted with impasto, to correct the painting means changing it for the worst, dirtying the colors and marring the harmony achieved. Rectifications are only advisable when the color is dry or almost dry. The color may be even denser if we leave it on newspaper for a couple of days to release oil.

Impasto can be worked using either a brush or a palette knife. The texture of the finish depends on the utensil used and the way it is applied. The brush forms very marked grooves, whereas the palette knife leaves the color thicker and flatter.

When using the impasto technique, some brushstrokes cover the others, partially blending into one another. We should therefore avoid overdoing it as all of the colors would end up forming a confused mass of paint.

Ochres are thicker than orange shades and cover them completely.

We have kept these thick reds clean by not applying another color on top.

The thick yellow covers the red and blends partially with it due to consistent brushwork.

The thick white does not cover the thick ochre but instead lightens it.

Brushwork

It is possible to finish an oil painting without leaving any signs of the brushwork. Nevertheless, most artists prefer visible brushstrokes as these touches of color also have their own artistic value. The brushstrokes give life and vibrancy to the work. Whether in the shape of commas, points, or strokes, brushstrokes should build up the shape of the object without losing their own shape, especially when we are working with very creamy color. The direction of the brushwork also matters, and it is important that we vary this direction to prevent monotonous results.

By alternating flat and round brushes of different sizes, we get distinctive-looking brushstrokes. Each plays a particular role in depicting the objects.

Brushstrokes made with the tip of a round brush.

Brushstrokes applied with a flat brush.

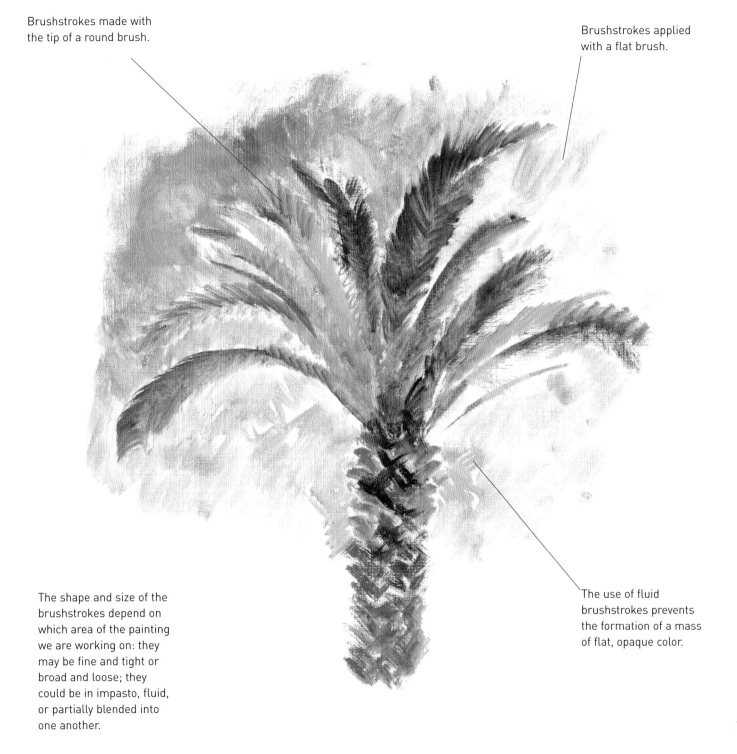

The shape and size of the brushstrokes depend on which area of the painting we are working on: they may be fine and tight or broad and loose; they could be in impasto, fluid, or partially blended into one another.

The use of fluid brushstrokes prevents the formation of a mass of flat, opaque color.

Mixing colors

The result of any mix of two or more colors can be predicted, bearing in mind the basic mixes between the three primary colors: blue, red, and yellow. A mix of blue and red gives violet; blue and yellow give green, and yellow and red give orange. These results vary depending on which blue, red, and yellow we use, but this is the general rule. The proportions of each color in the mix, as well as the degree of saturation, are also crucial factors. It is advisable to start with the lightest color and progressively add small amounts of the darkest color until achieving the required tone.

The three primary colors give rise to the rest of the basic colors on the palette. This does not mean that we have to paint with just three colors, but that it is important to remember the results of the basic mixes so that we can predict the colors that we will obtain.

This circle shows
the basic range of
colors that we get
from mixing the
three primary
colors: blue, red,
and yellow.

primary yellow

secondary orange

secondary green

primary red

secondary bluish green

secondary violet

primary blue

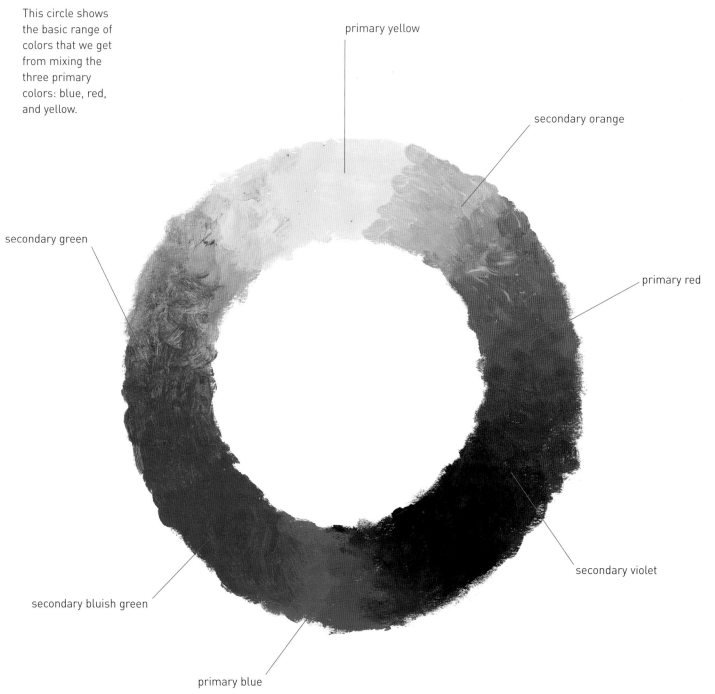

The processes
of oil painting

A jug:
brushwork and modeling in chiaroscuro

Modeling in chiaroscuro is one of the simplest techniques in oil painting. It basically consists of gradating a color toward a darker shade using colors from the same range, or toward a lighter shade through the use of white paint. Black is not used here to prevent the color from becoming too gray.

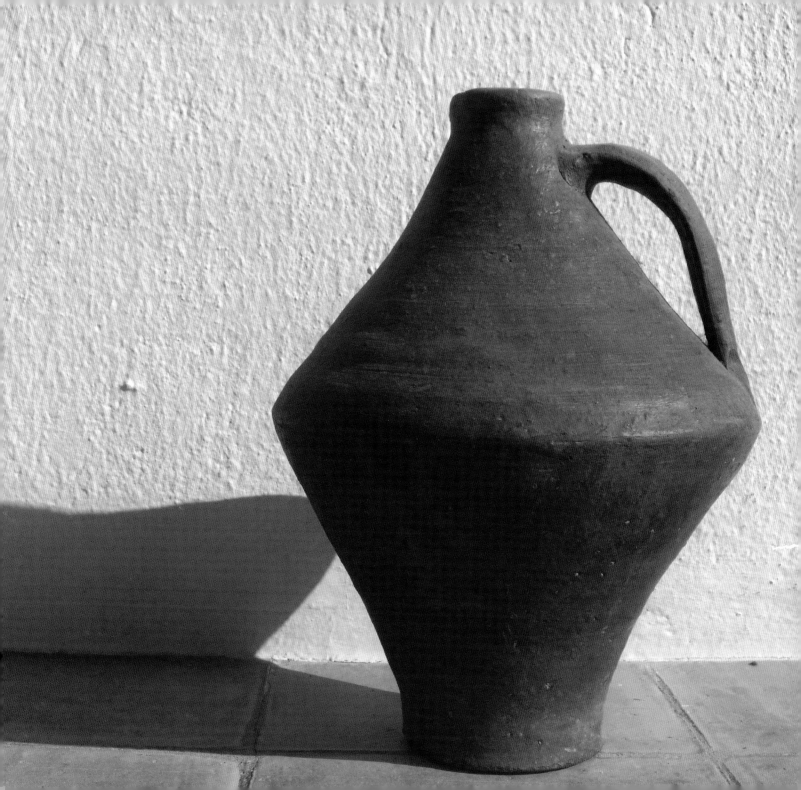

The colors we need

In this exercise we have used very few colors: yellow ochre, burnt sienna, burnt umber, ultramarine blue, and cadmium red. In addition we need titanium white to lighten some hues.

burnt sienna

burnt umber

yellow ochre

cadmium red

ultramarine blue

The drawing

The drawing provides a simple outline of the jug's contours. This is easy to achieve, involving no more than ensuring the symmetry of the container and adapting the size to the format of the support. We have first sketched it in pencil and then gone over it in pink, diluted with a lot of turpentine.

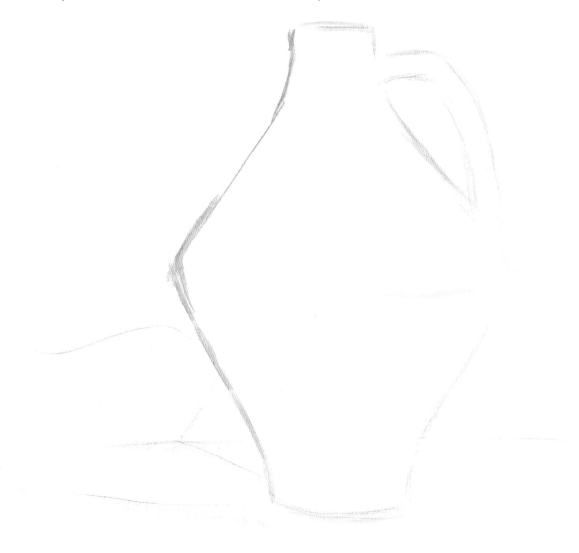

The block-in phase

The uniform tone of the jug aids blocking in, which is done with burnt sienna diluted with a lot of solvent. We work loosely, applying rapid horizontal brushstrokes from the top to the bottom of the container.

2 | The shadow is darker toward the central part of the jug, and it is here where we need to build up the brushwork in slightly less fluid burnt sienna.

1 | The dilution of the burnt sienna paint helps the brush slide easily on the support.

3 | We now work with very little turpentine, just enough to keep from applying the color too thickly.

The block-in
phase is finished:
this will provide
the basis for
the distribution
of light and
shadows.

1

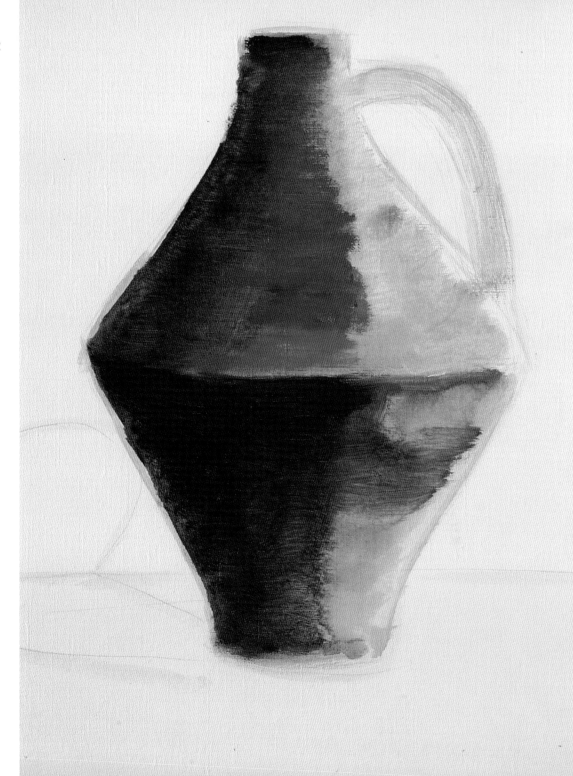

Shades of chiaroscuro

This chiaroscuro could be created with just one color, but it is much more interesting to incorporate hues from the same earthy range: ochre in the light shades and burnt umber in the darks.

1 | Mixed with white, ochre gives yellow, but when thinned down with burnt umber it brings about this somewhat grayish light tone.

2 | A single ochre brushstroke is enough to define the lit area of the handle.

3 | A stroke of burnt umber is sufficient to provide shadow.

The choice of the range of earth colors and the use of systematically horizontal brushwork both add equally to the final result.

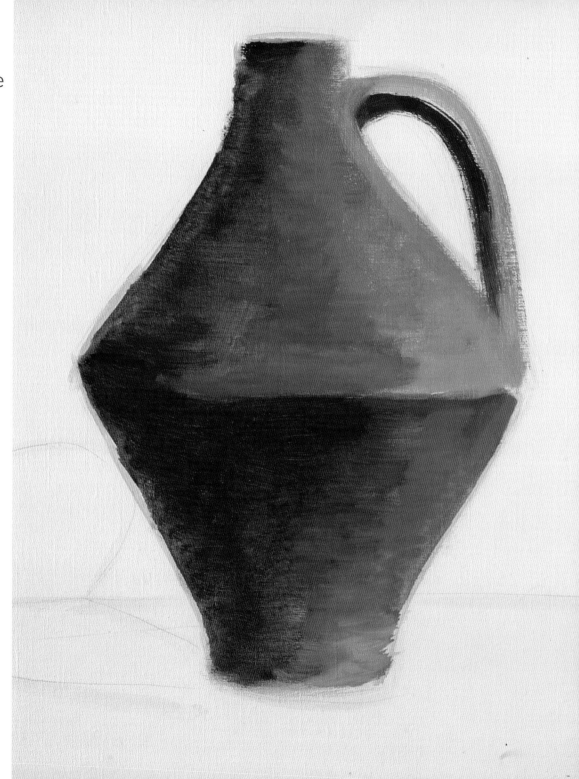

The background and the projected shadow

With the jug finished, all that is left to do is cover the background in a cool and light tone, color in the plane that the jug rests on, and define the projected shadow. This is a rapid process that is very easy to do.

1 | We paint the shadow in a tone that comes from mixing burnt sienna and a small amount of blue, with a little white to lighten the shade.

2 | This pink is a mix of cadmium red and white. We apply this along the entire base of the composition, avoiding making the brushstrokes too visible so that they contrast with the jug.

3 | We can evoke the rough background with random brushwork in light blue mixed with a little burnt umber.

The process has
been quite fast,
and problems
with shape or
color have not
arisen. This is a
simple subject
and an effective
method.

3

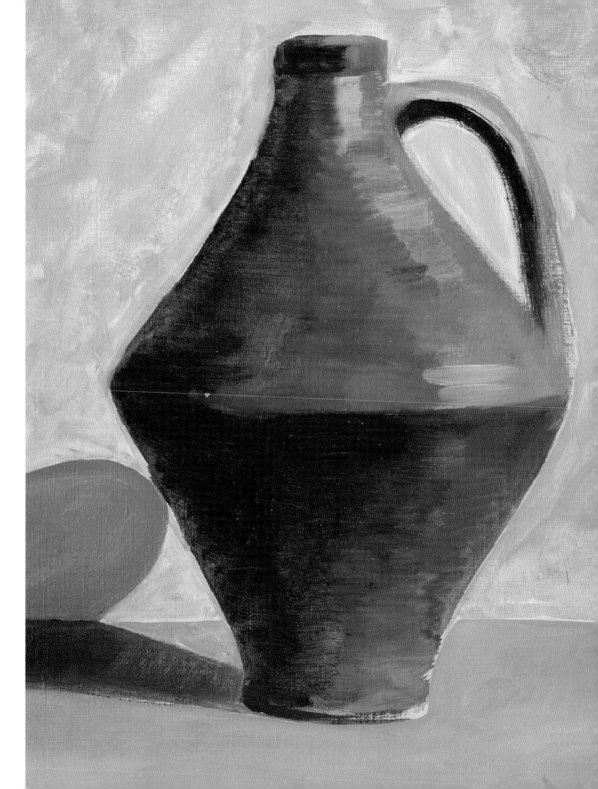

Two sunflowers:
colorful impasto

The richness of a pictorial fabric made up of abundant pigment is one of the delights of oil painting. This exercise demonstrates how to obtain a luminous and sensual result working with thick and vibrant colors.

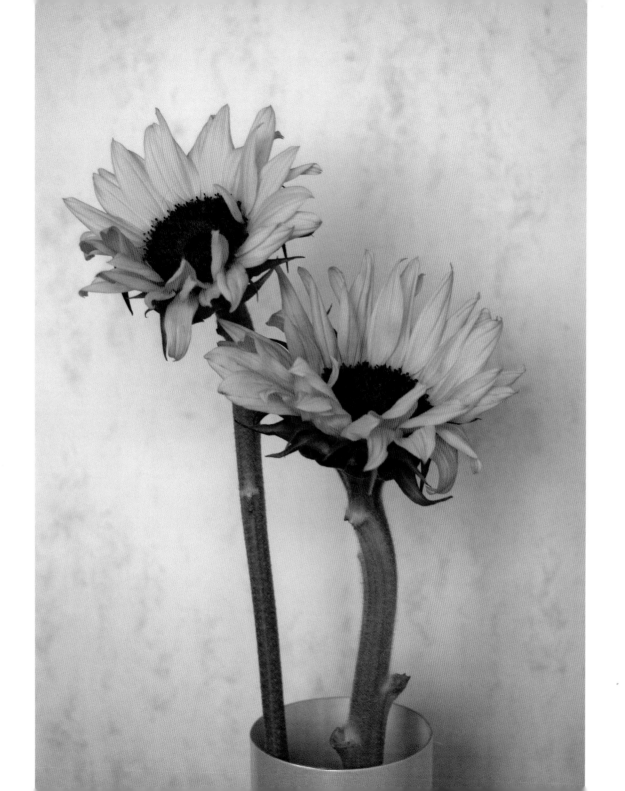

The colors we need

We have six colors on our palette: cadmium yellow, yellow ochre, carmine madder, raw umber, permanent green, and permanent blue. Naturally, we should add titanium white to this list.

cadmium yellow

yellow ochre

carmine madder

raw umber

permanent green

permanent blue

The drawing

This is a very simple sketch where the petals of each sunflower are defined using yellow strokes. The color has previously been diluted with turpentine to prevent lumps of paint.

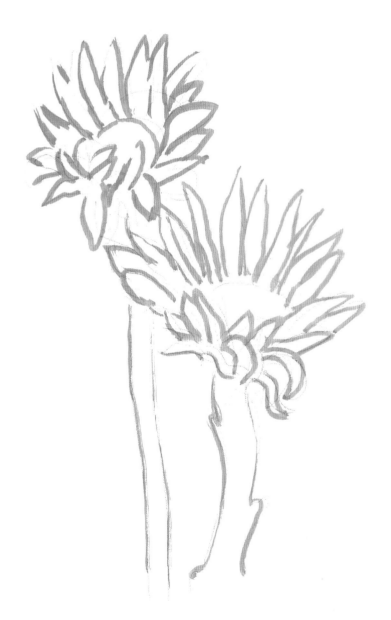

First, the diluted color

Thick color is difficult to modify without dirtying it, so we start by blocking in the whole canvas with the colors diluted with a lot of turpentine. If something goes wrong, we can remove the brushstrokes by rubbing them with a cloth.

1 | We first paint the background in blue lightened with white to which we add a tiny amount of carmine. We apply the color fairly thickly and we "stretch" it out, that is, we spread it out progressively diluting it with turpentine.

2 | When all the background is painted, the color is now very diluted and it is very easy to finish covering the canvas.

3 | We paint the petals one by one. Occasionally, we should mix the yellow with a little ochre to differentiate some of the petals from the others.

Once we have almost the entire canvas covered in color, it is time to apply impasto, or in other words, to work with thick color without the use of turpentine.

1

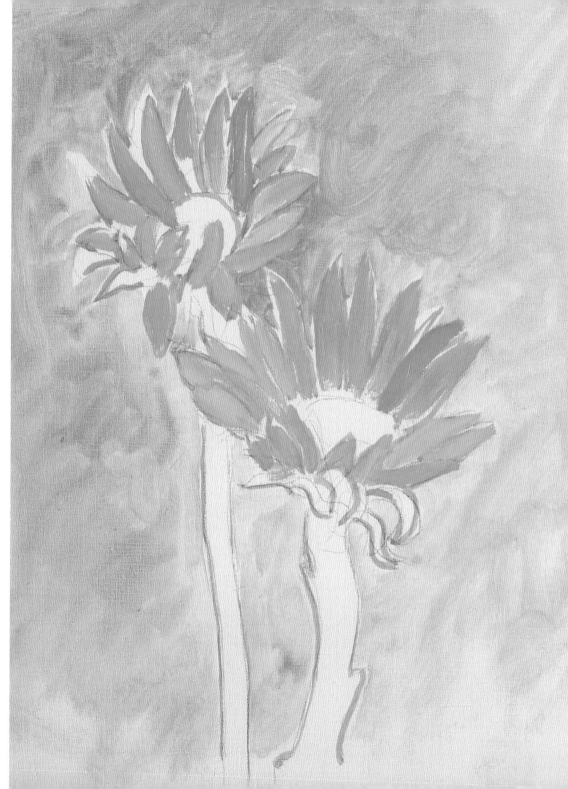

Undiluted color

Now we use the colors as thickly as they leave the tube. The brush should be completely dry before dipping it into the color, and there should not be too much color on the brush as we would otherwise create lumps on the canvas.

2 | We paint the stems with long brushstrokes of unmixed green without adding turpentine.

1 | We cover the center of the flowers with an area of undiluted raw umber.

3 | The color is now very dense and allows us to cover the previous brushwork, modifying its color with somewhat lighter or somewhat darker tones than the initial yellow.

After this simple
process of
applying
brushstrokes
representing
petals, we can
consider the
flowers
completed.

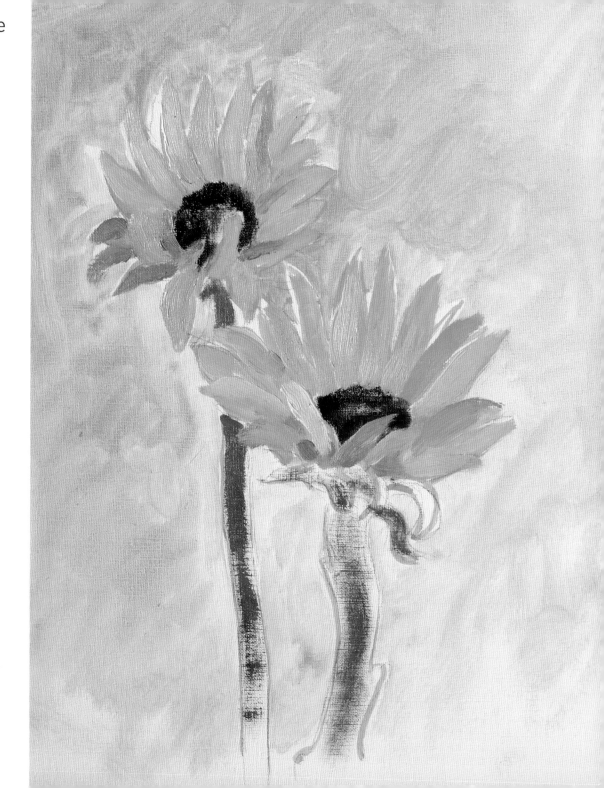

The stems and the background

When painting the background we can apply a lot of thick paint without the fear of creating lumps, as the surface that we are going to cover is large and there is always the possibility of using the brush to spread out the excess color that has built up in an area.

2 | We paint the stems with thick brushstrokes of green mixed with white.

1| We create the small green leaves that make up the flower's calyx with simple thick brushstrokes of green mixed with blue and some yellow.

3 | We go over all of the blue of the background with a blue lightened with white; this mix should be as thick as possible.

The creaminess of the paint gives a dense and textured finish. This is the unmistakable effect of painting with oils.

3

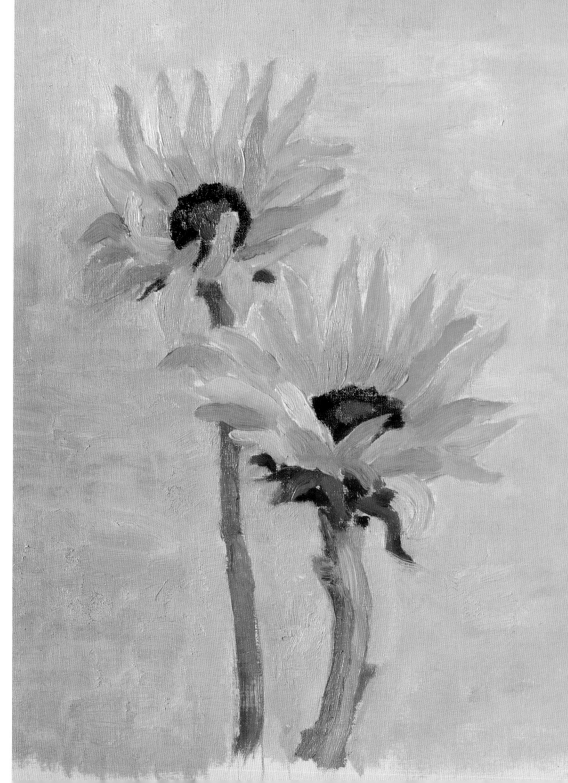

A plant pot: modeling color

We can create the effect of light and shadow through the gradation of color. In this exercise, we will see that convincing modeling can easily be done if we work with a simple range of colors that represent the transition from light to shadow.

The colors we need

The whole plant pot can be painted using shades of three warm colors: cadmium yellow, cadmium orange, and burnt sienna. Other colors used are permanent green, cadmium red, and cerulean blue.

cadmium yellow cadmium orange burnt sienna

permanent green cadmium red cerulean blue

The drawing

The drawing made prior to painting should be as simple as possible, without concentrating on the details. Before drawing the lines with this orange color (diluted with a lot of turpentine), we can sketch them with a pencil and then simply go over them.

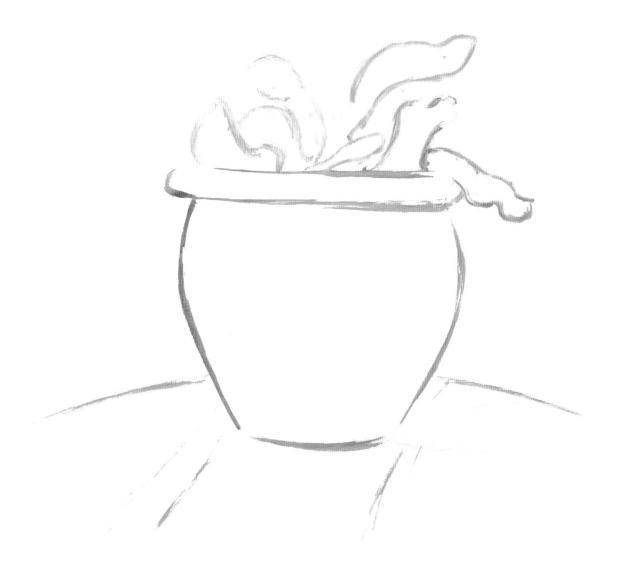

From light to dark

We start with the modeling of the plant pot. We will work with a fairly thick flat brush that allows us to cover the entire surface using broad brushstrokes. Dense color is easier to control than diluted color so we therefore use very little turpentine.

1 | The first color is the lightest: orange mixed with yellow. We use it to cover the illuminated area up to the edge of the shadow.

3 | We repeat the same operation with the burnt sienna: we paint in the shaded part and blend in the color using brushstrokes that progress from light to dark.

4 | We shade in the relief of the rim of the plant pot with a simple stroke of earth color applied in the center of the orange band.

2 | Next, we work with the unmixed orange, which is applied in the center of the plant pot. Once this area is painted, we blend this orange and the previous one, applying brushstrokes from the light color to the dark.

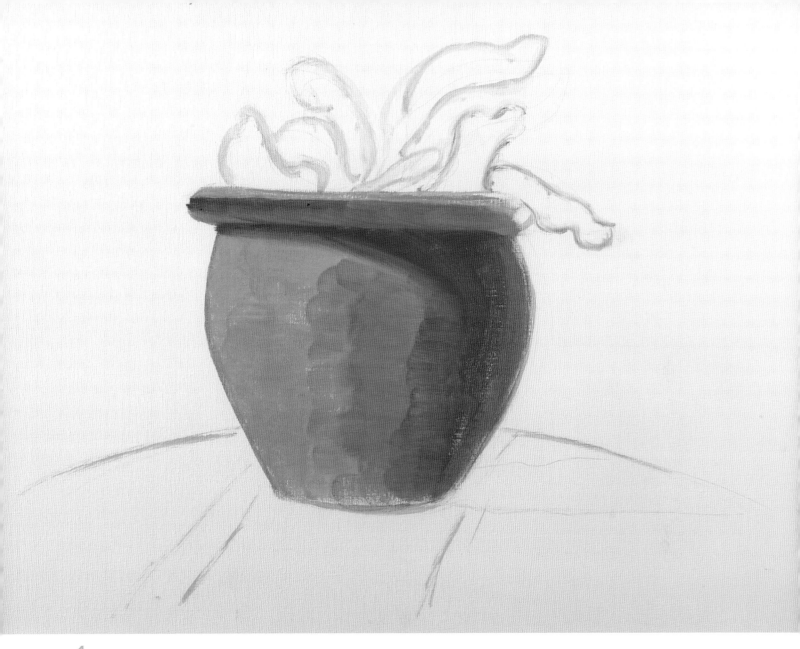

1 This modeling process is fairly elementary and very effective. It is important not to retouch the color blending too much, or the tonal contrast can lose strength and clarity.

Gradating the background

Creating the transition from light to shadow in the background is even simpler than the gradation of the plant pot. It consists of covering the canvas with a light color and blending it with a darker shade on the shadowed edge. We should work with undiluted paint.

1 | For the background we take the same burnt umber that we used on the plant pot, but lightened with a lot of white. This brushwork brings the color very close to the edge of the container.

2 | To neatly outline the edge of the plant pot without overlapping, we apply the color with the upper edge of the brush and carefully spread it out.

3 | We create the darkest area by painting a vertical strip in the same color (without mixing this with white). Later, we blend this strip with the lighter color, using horizontal brushstrokes from the lightest to the darkest.

2 We have carefully followed the contours of the drawing of the leaves to leave them in reserve. Despite being very broad, the flat brush allows this careful outlining.

The leaves and the tablecloth

We can create the plant's leaves using irregular areas of paint that suggest the light and shadows without needing to depict them precisely. The tablecloth is a question of contrasts between ungradated colors.

1 | We cover all the leaves with brushstrokes of green diluted with a lot of turpentine, using a finer round brush. The combination of brushstrokes with different densities creates relief in itself.

2 | We reinforce the effect of relief by applying brushstrokes of undiluted green in the most heavily shadowed parts of the leaves.

3 | The shadow projected by the plant pot is a dark band painted in a color that is the result of mixing raw umber, blue, and red.

4 | We create the pattern of the tablecloth by working with undiluted color and applying the brush gently so that the color does not completely cover the support, evoking the texture of this pattern.

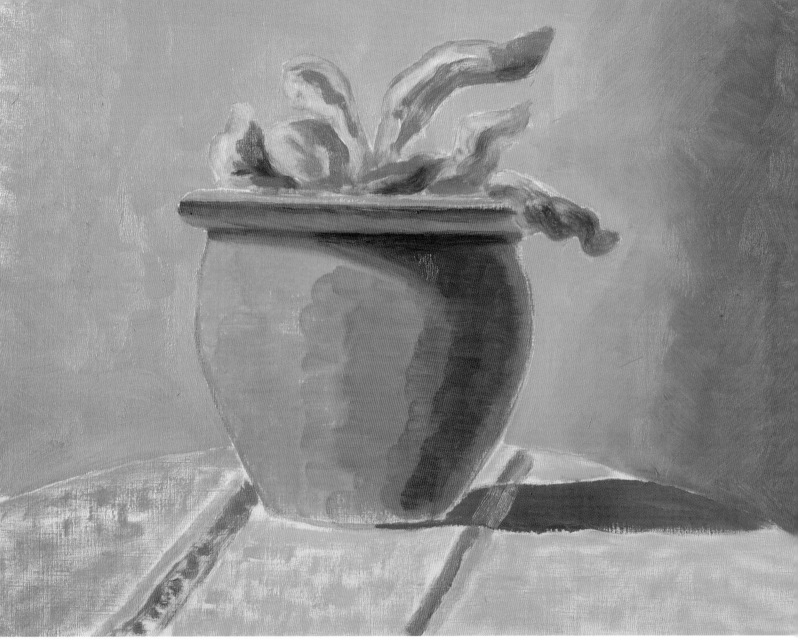

3 Modeling gives us a realistic, sober, and grounded depiction of light and shadow, without unnecessary features or shades.

Fruits:
creating color

It is not necessary to work in chiaroscuro to depict the volume of an object. Relief can be highlighted by shading different colors without overdoing the dark colors. This exercise shows a simple and colorful way to create relief.

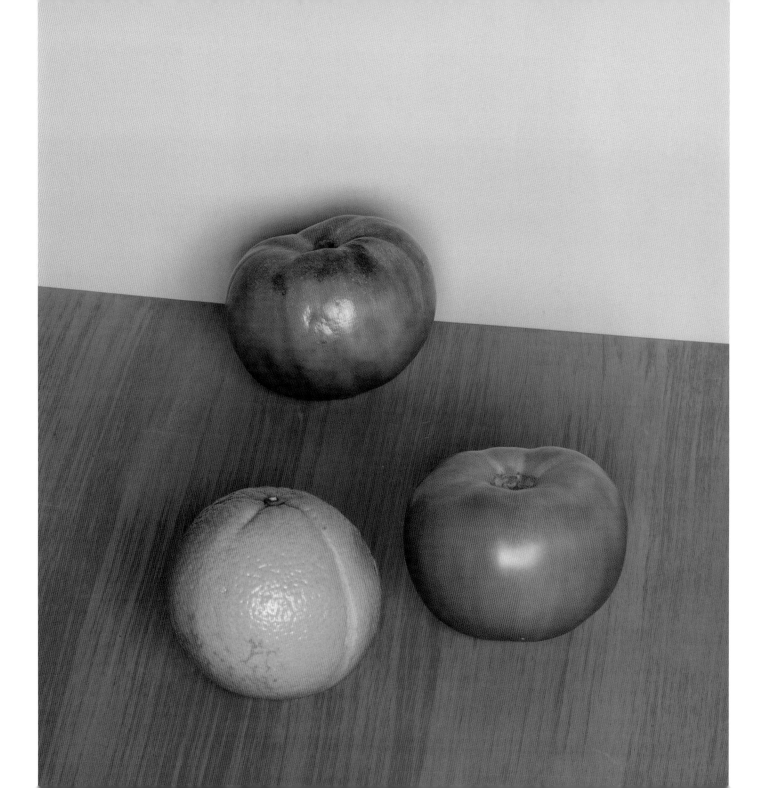

The colors we need

We will use a total of six colors: cadmium yellow, cadmium orange, carmine madder, chrome green, cerulean blue, and ultramarine blue. Titanium white is also added to this list.

cadmium yellow · cadmium orange · carmine madder

chrome green · cerulean blue · ultramarine blue

The drawing

This drawing can be done directly with the tip of a brush using a light color (ochre, pink, or orange), diluted with a lot of turpentine. If we do not feel very comfortable working in this way, we can first make a sketch using a pencil.

The fruits one by one

This exercise consists of three separate fruits; we create them one by one to show the process as clearly as possible. We will start with the orange.

1 | We cover the surface of the orange with small orange brushstrokes in different shades (mixed with differing degrees of yellow).

3 | The brushstrokes should not completely cover the fruit: we leave a small unpainted area that describes the light shining on the lustrous skin of the orange.

2 | We go over the side of the fruit with most shadow using brushwork in ochre, which, by contrast, is darker than the rest of the orange.

The accumulation of small brushstrokes in different shades suggests the texture of the orange.

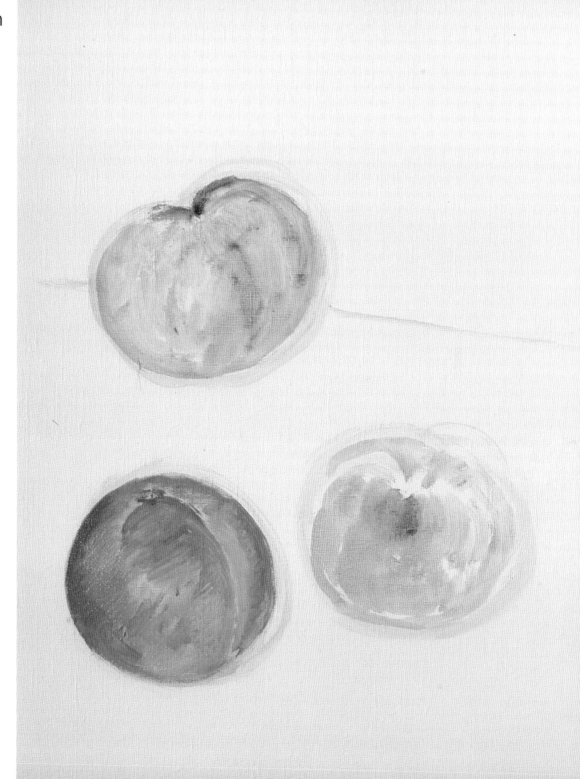

1

From pink to green

The skin of one of the tomatoes has a coloring that combines red, pink, and light greens. Let us look at how we can handle this.

1 | We first spread out the colors diluted with a lot of turpentine: green around the outside of the fruit, and red in the center.

2 | Where red and green overlap, we add a little white so as not to darken the mix, always painting with a small amount of color.

3 | We create the shine on the skin in the center of the fruit by adding a few brushstrokes of pure white.

The tomato
has a delicate
combination of
colors. We should
use very little
paint to prevent
murkiness.

2

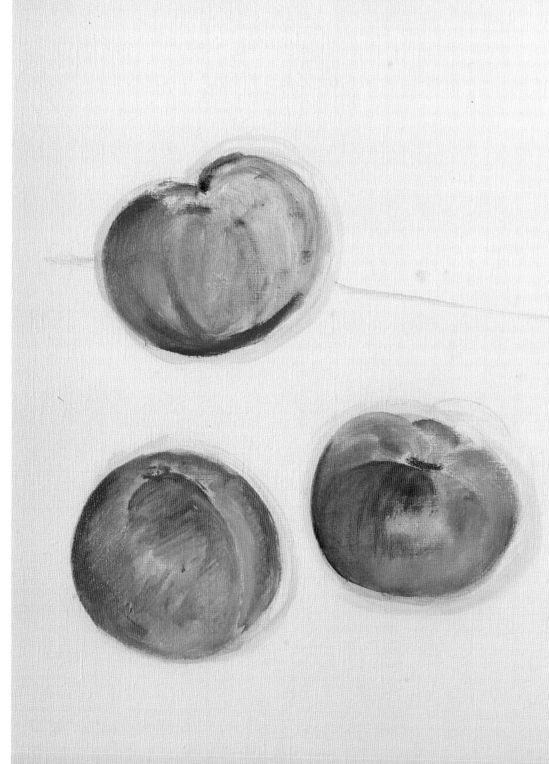

Modeling with green

The modeling of the second tomato is even easier than the previous example: it is simply a matter of creating a monochrome gradation in green.

1 | First, we color the whole fruit with the green diluted with a lot of turpentine, leaving darker tones around the edges and lighter ones in the center.

2 | We go over the outside of the tomato with brushstrokes of green, which is undiluted and therefore darker.

3 | We leave the center of the tomato without retouching so that it appears lighter. We darken all the tones around it, mixing the green with a little blue.

4 | The background is painted in blue mixed with white (we use more white at the top than at the bottom). We paint the shadows of the fruits with unmixed blue.

Without the need for dramatic contrasts of chiaroscuro, we have successfully modeled each fruit. There is no reason why the clarity of the relief should sacrifice the richness of the color.

3

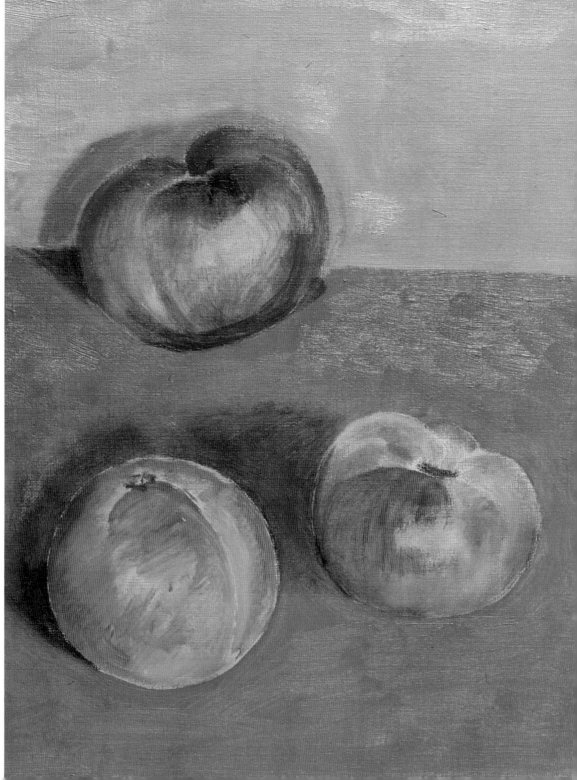

Toys:
painting with a palette knife

Painting with a palette knife involves working with creamy colors straight from the tube. The palette knife enables us to apply much more paint than a brush. It also offers a way to create large areas of perfectly homogeneous color. The subject of this exercise invites the use of this painting method thanks to the purity and saturation of the colors of the toys.

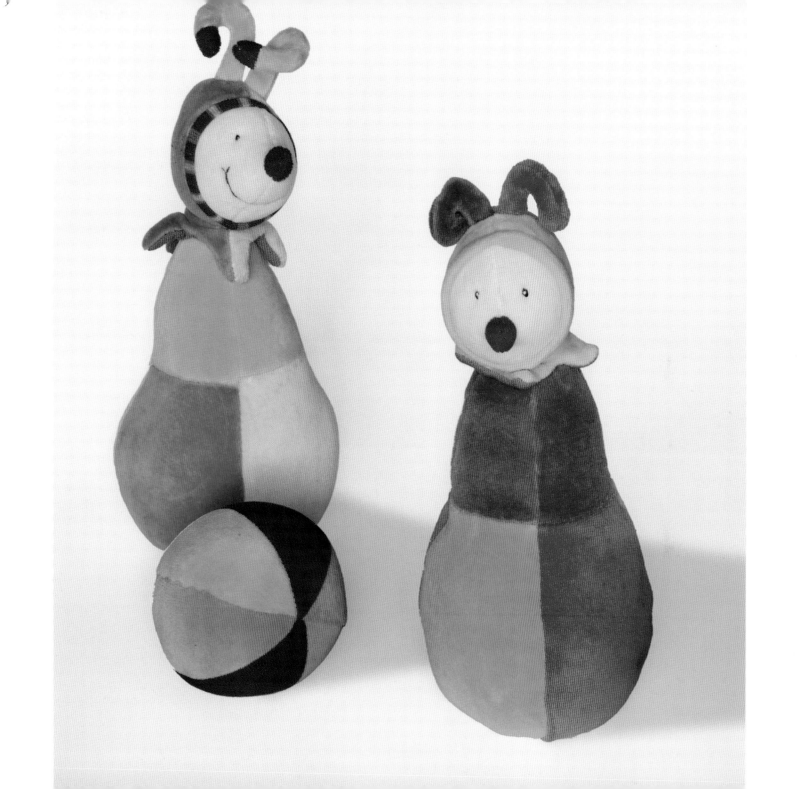

The colors we need

We have chosen the most vibrant colors on the palette: cadmium yellow, cadmium orange, intense red, emerald green, light cobalt blue, and dark cobalt blue. Naturally, we have also used titanium white.

cadmium yellow

cadmium orange

intense red

emerald green

light cobalt blue

dark cobalt blue

The drawing

In this exercise, it is important to simplify the initial drawing as much as possible, as it is absolutely impossible to correct slight details that break away from the overall shape when painting with a palette knife.

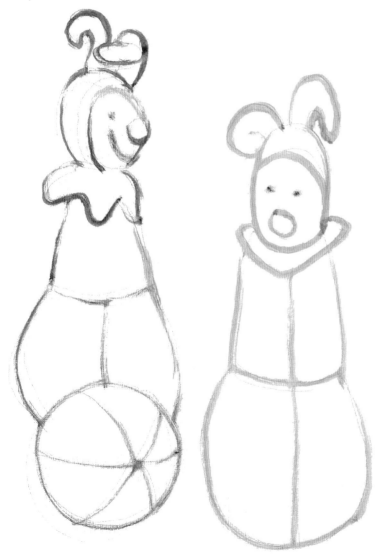

First, the background

When working with a palette knife it is difficult to keep the color clean. To ensure a clean-toned background, we paint this first.

3 | To cover the larger spaces, we spread out the color by rubbing it onto the canvas. This keeps the thickness of the layer of paint on the support to a minimum.

1 | First, we paint the background to create tonal contrast for the saturated colors that we are going to use. The gray paint used comes from mixing orange, blue, and white.

2 | We paint the yellow areas, following the guidelines set by the drawing.

The painting process is very elementary, and the most difficult part is staying within the lines of the drawing.

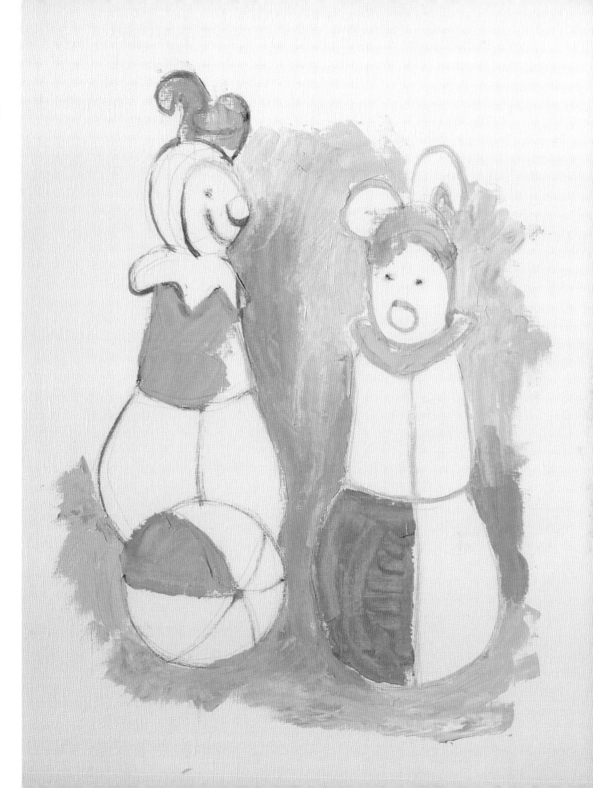

1

Adding color and the details

Although the palette knife does not allow us to work on the finer points, it is possible to work on meaningful details without ruining the effect of the whole.

1 | When placing one area of paint next to another, it is better to leave a space between them. We will cover these spaces later, working carefully.

2 | We create the detail of the cap with a twist of the palette knife loaded with little color. This is a single application or "stroke" of the palette knife.

3 | When we use the palette knife to scrape the color, we achieve slight transparency from the white of the support that lets us obtain lighter shades.

We gradually cover each area with the right color, always seeking the maximum contrast.

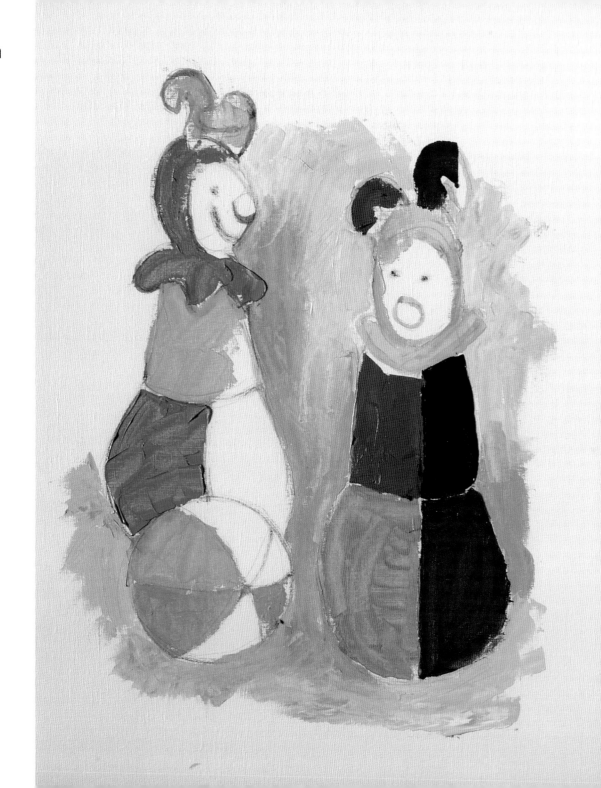

The finishing touches

We use a very fine round brush for the smaller details because the palette knife does not allow us to do such detailed work.

1 | We work carefully on the ball, concentrating on its curved outline.

2 | We can use the flexible tip of the palette knife to add detail to certain areas, although we should not attempt to work on the smallest details with it.

3 | Once the work is almost completed, we use a fine, round brush to paint the dolls' faces.

This is a very
basic work, ideal
for starting out in
the palette knife
technique.

3

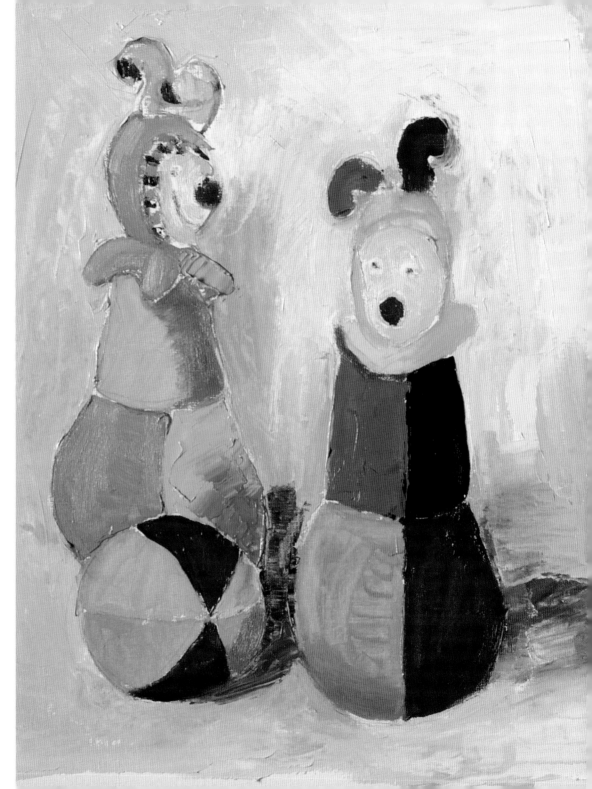

A fruit bowl:
contrasts of pure color

This painting involves much more work than the previous projects, but it is not more difficult. The subject presents us with more aspects to be painted; there are more contrasts between colors, more shades, and more details. It requires a little patience but basically consists of applying the main principles of oil painting.

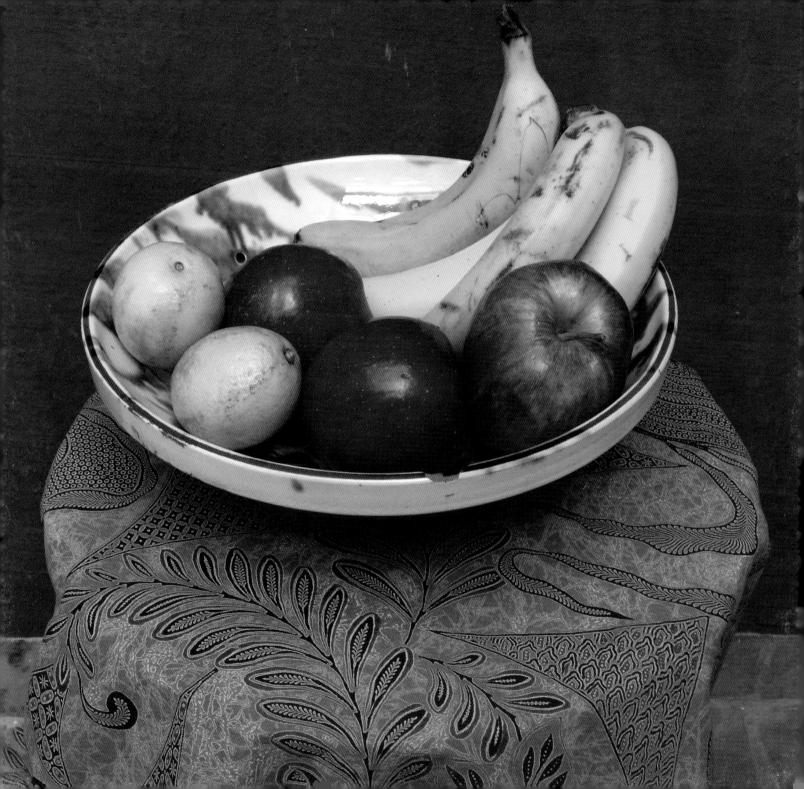

The colors we need

We work with a palette made up of cadmium yellow, yellow ochre, permanent red, carmine madder, ultramarine blue, and cobalt blue. These colors are more than sufficient to achieve a great abundance of shades.

cadmium yellow

yellow ochre

permanent red

carmine madder

ultramarine blue

cobalt blue

The drawing

The key to this drawing lies in sketching the two ovals corresponding to the fruit bowl and the table. They should be well-centered on the paper. The fruits are represented by further ovals, and the bananas are easily outlined in a few strokes. The color used is orange diluted with a lot of turpentine.

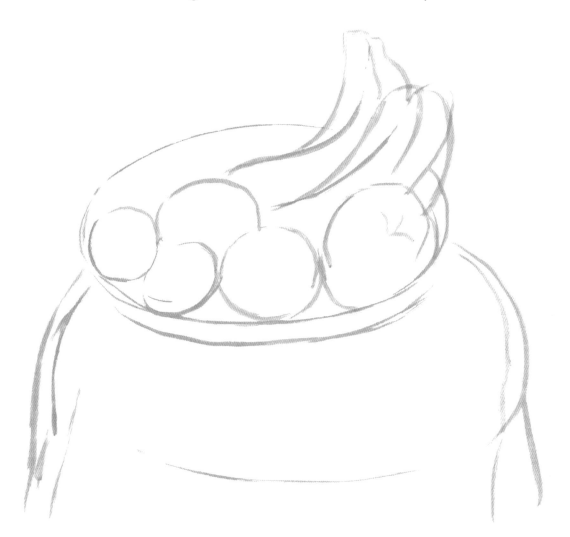

Blocking in the canvas

We first cover the entire composition with the colors that correspond to each object diluted with a lot of turpentine. This is not at all complicated.

1 | We use yellow to paint in the lemons and bananas. To contrast the latter, we can paint one of them with the thickest color or, in other words, the darkest color.

2 | We alternate carmine and permanent red in the red of the apples to avoid repeating the same shade.

3 | Before completely painting in the cloth that covers the table, we recreate an approximate sketch of its pattern by using broad areas of ochre.

Once we have
reached this
point, we have
done the most
difficult part. The
pale areas of
color will serve
as a guide from
this point on.

1

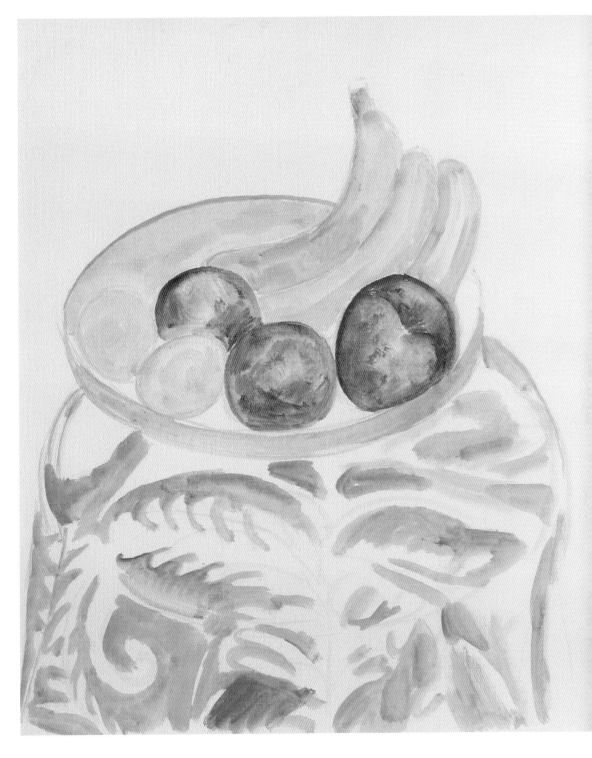

Light impasto, gentle modeling

We should now create relief on top of what has already been done by painting with somewhat thicker colors, without overdoing the amount of paint.

1 | To model the lemons, we cover them with a saturated yellow, but leave the center of the fruits unpainted.

3 | As with the lemons, we darken the outer edges of the apples, painting with color that is highly saturated but not too thick.

4| The center of this fruit has some green shades that have to be applied carefully, trying not to blur these brushstrokes with the surrounding red.

2 | The bananas call for saturated yellow to be alternated with ochre so that each banana is somewhat lighter or darker than the adjacent fruit.

Through a simple
process of color
saturation, we are
enhancing the
volume of each
object in the
composition.

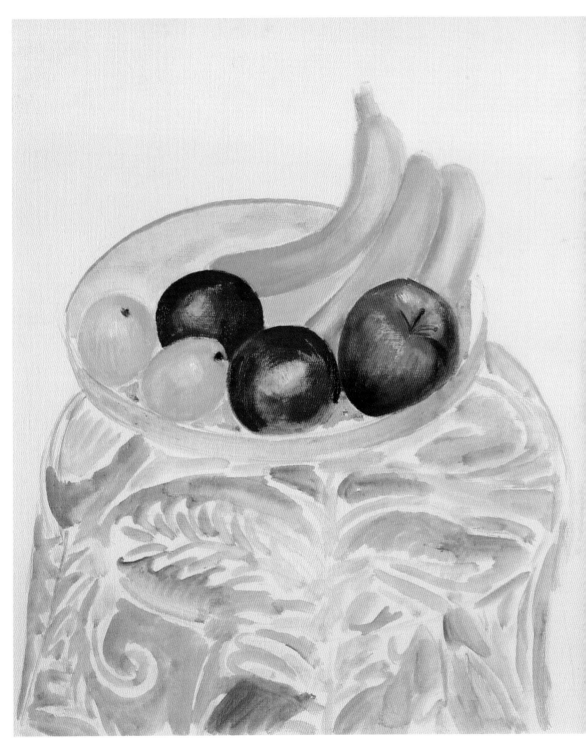

2

Enhancing the contours

To liven up the relief of the painting even more without needing to darken the shadows, we enhance some of the contours by using dark strokes.

2 | A broad brushstroke in a cream color is sufficient to define the edge of the fruit bowl.

1 | Using a mix of carmine and blue, we run along the outside of the fruits creating a dark stroke that is not too thick. We only paint where the fruit touches the fruit bowl.

3 | Underneath the previous brushstroke, we emphasize the shadow of the fruit bowl with a stroke of ochre mixed with carmine.

The fruit bowl and
its contents are
now completed.
The easiest part
is left to do: the
cloth and the
background.

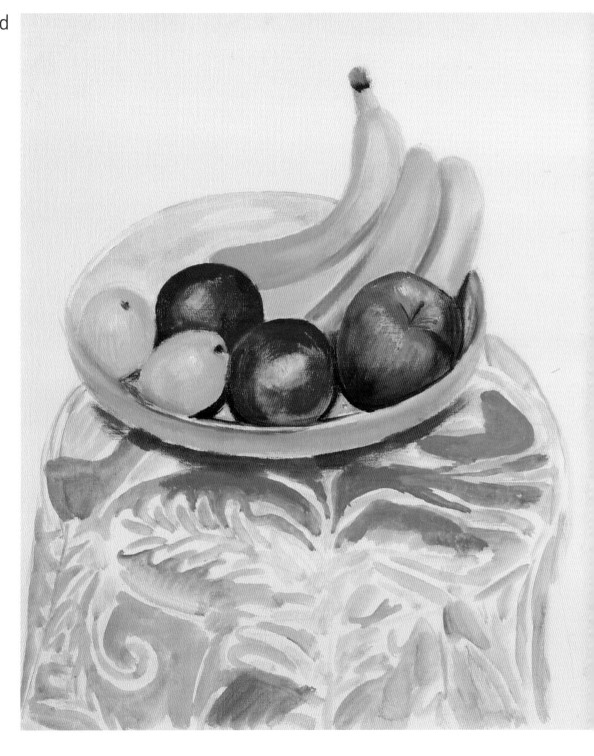

3

Patterns and details

We should not be overwhelmed by the intricacy of the patterns. There is always an easy and effective way to do this by focusing only on the essence of the pattern.

1 | We should work on the ochres up to the limits set by the drawing in blue; we do not try to concentrate on all the finer points, just the general drawing.

2 | The bottom of the tablecloth should be darker than the top. Each shade of ochre marks out the drawing of the pattern a little more.

3 | When the drawing of the tablecloth has been defined, we paint the background in blue mixed with a little carmine and lightened with white.

The precise, clean finish is the result of an ordered and simple process, without complex mixes or excessive impasto.

4

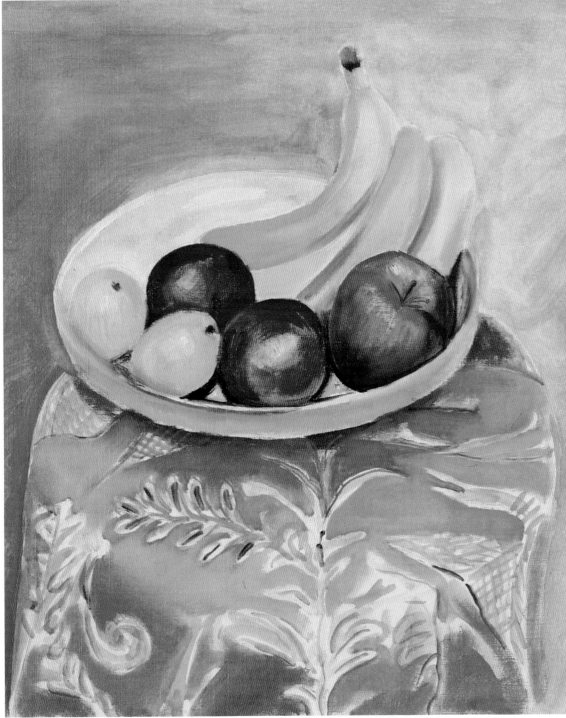

Expressive brushwork:
landscape with palm tree

This work requires a certain amount of simplification. The leaves of a tree, in this case a palm tree, cannot be depicted one by one, but rather must be approached in a general fashion. The brushwork will be the factor that allows us to suggest all the palms by actually depicting just a few of them.

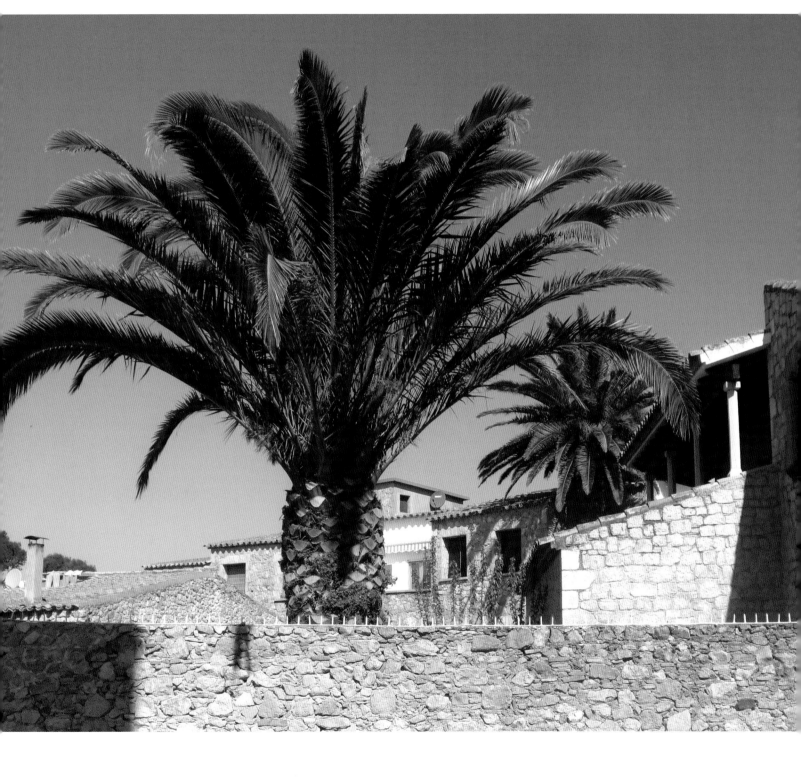

The colors we need

We use a palette made up of cadmium yellow, yellow ochre, ultramarine blue, carmine madder, permanent green, and cobalt violet, as well as titanium white.

cadmium yellow

yellow ochre

ultramarine blue

carmine madder

permanent green

cobalt violet

The drawing

This drawing, done directly with the brush, shows the true essence of the subject. Everything has been reduced to several straight lines and very simple curves. It has been drawn with the brush dipped in thinned-down violet. If you prefer, this drawing can be done beforehand in pencil.

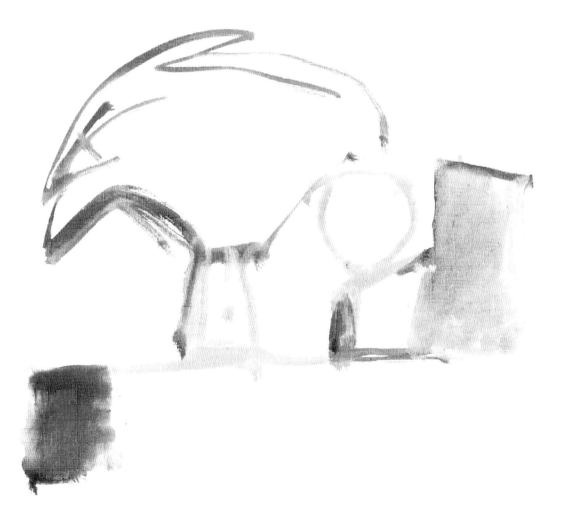

The block-in phase

The block-in phase of the painting means establishing the large shapes of color as simply as possible. The color is reduced to two or three tones applied roughly in large blocks.

1 | With a flat brush dipped in very diluted violet, we paint the inside of the palm tree using broad and simple strokes.

3 | We rub gently on the canvas with a cloth to unify the tones, and we absorb any excess color so that this does not dirty the new colors that are to follow.

2 | After mixing the violet with more blue, we paint in the rest of the shapes in the drawing, keeping the color well-diluted at all times.

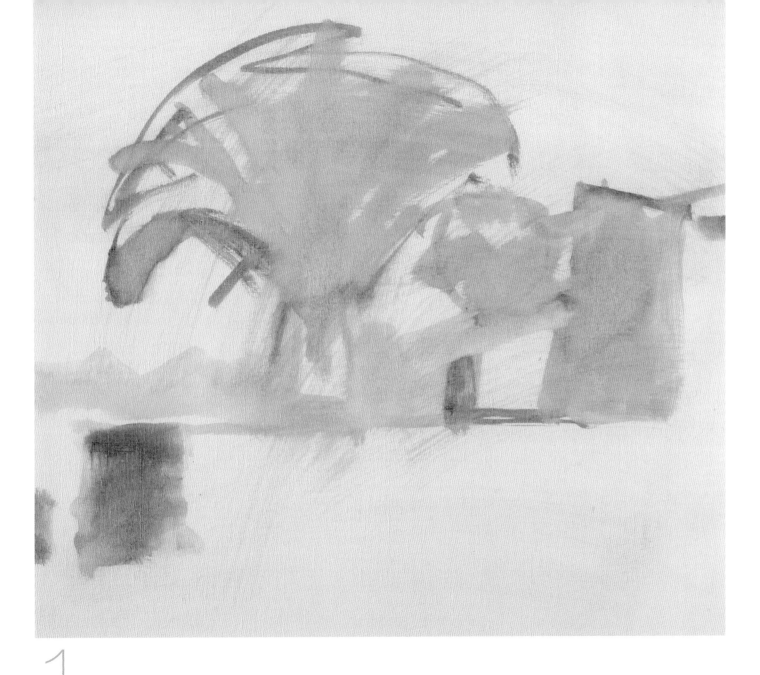

1 The blocked-in areas of paint on the canvas will guide us during successive applications of color.

The shape and the background

The contours of the palm tree are defined against the blue of the sky. By painting this blue we are also creating the outline of the large palms.

1 | We mix ultramarine blue with white until we get a medium blue ("sky blue"), and we use a round brush to paint the background, outlining the palms of the palm tree.

2 | The buildings are also part of the background: we paint them in a warm gray tone that is a mix of ochre, white, and a small amount of blue.

3 | We cover the empty space of the sky with substantial brushstrokes of light blue, using fairly thick color.

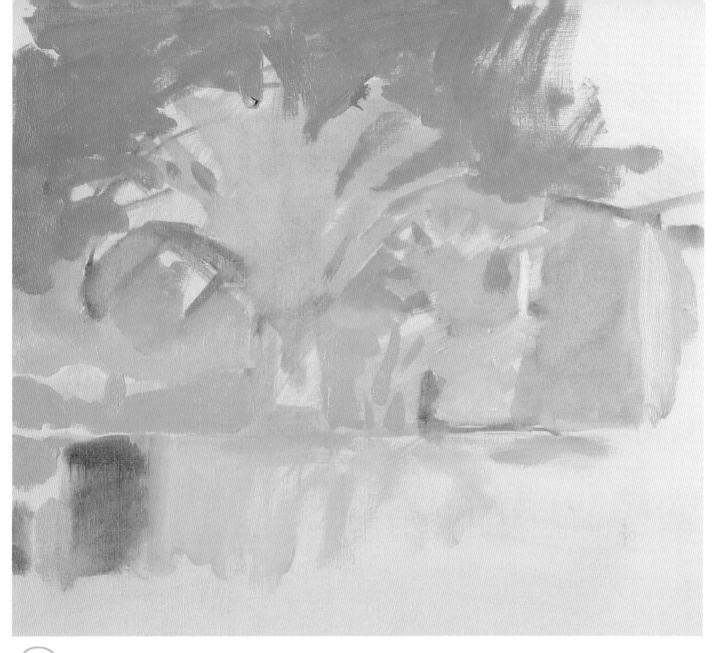

2 We pick out the shape of the palm tree against the sky and can now distinguish between nearby and more distant areas.

Applying color using impasto

To represent the shape and color of the palm tree, we can add touches of color or use small brushstrokes.

1 | Using the round brush, we apply short brushstrokes of unmixed green in the shape of a comma to different areas of the palm tree.

3 | Each application of color has a different shape, such as a zigzag, comma, or straight line. This variety lends vibrancy to the color and feel of the plant forms.

2 | Violet and blue shades are used to describe the shadowed areas alongside the green shades, which are those that receive the light.

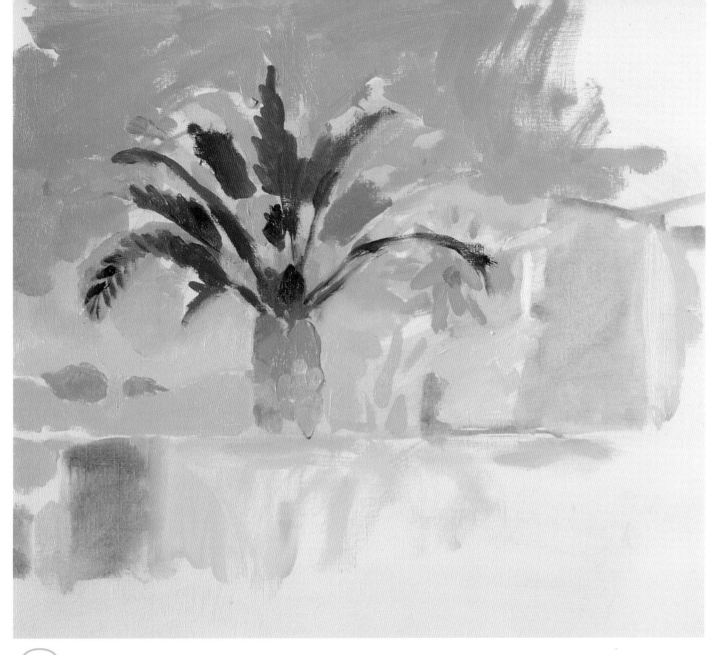

3 The multicolored areas create an impressionist effect. The palm tree is expressed by the interplay of light and shadows without the need for additional details.

The finishing touches

The buildings in the background still need to be worked on; they are now just amorphous spaces. Some well-placed details will be enough to make sense of them.

1 | We should not darken the trunk of the palm tree too much so as not to detract attention from the painting of the palms. Violet lightened with white, without too many shades, is sufficient.

2 | We retrace the outlines of the walls and contrast them using mauve and bluish colors.

3 | Always using the blue-violet range, we emphasize the contrasts between the lit parts of the walls and the parts in shadow.

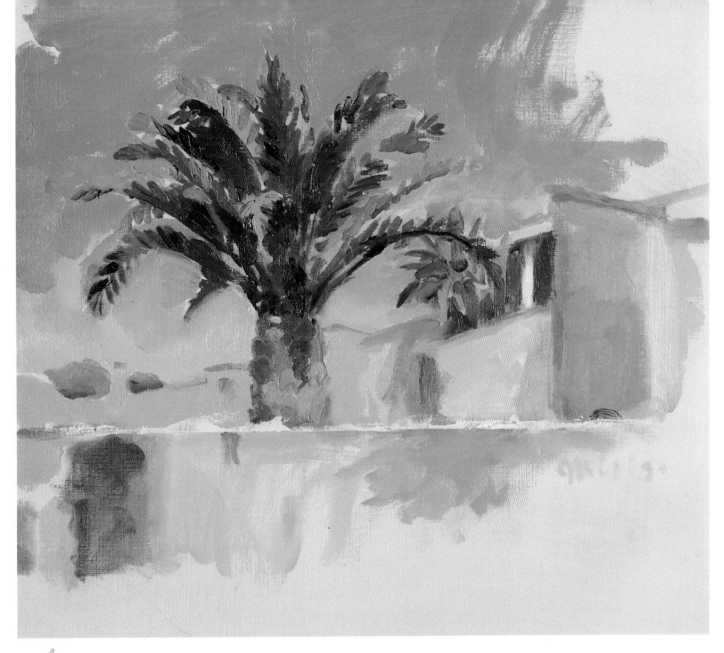

4 We could continue working on the painting, but this would be at the cost of losing its fresh look. It is better to leave it as it is. We have achieved a colorful effect, and that is the most important thing.

Project management:
Parramón Ediciones, S.A.

Publishing manager:
María Fernanda Canal

Editorial assistant and picture archive:
Mª Carmen Ramos

Text and coordination:
David Sanmiguel

Exercises:
David Sanmiguel, Mercedes Gaspar

Art direction:
Mídori

Graphic design:
Soti Mas-Bagà, Pilar Cano

Photography:
Archivo Parramón, Nos & Soto

Production manager:
Rafael Marfil

Production:
Manel Sánchez

Original title of Spanish book: *Atril: Óleo*
© Copyright Parramón Ediciones, S.A., 2009-World Rights
Published by Parramón Ediciones, S.A., Barcelona, Spain

English edition © copyright 2010 by Barron's Educational Series, Inc.

All inquiries should be addressed to:
Barron's Educational Series, Inc.
250 Wireless Boulevard
Hauppauge, New York 11788
www.barronseduc.com

Library of Congress Catalog Card No. 2009925785

ISBN-13: 978-0-7641-4438-7
ISBN-10: 0-7641-4438-3

Printed in China
9 8 7 6 5 4 3 2 1